Botanical REFLECTIONS

—— Capture Your Days in Words and Pictures ——

WestBow Press books may be ordered through booksellers or by contacting:

WestBow Press
A Division of Thomas Nelson & Zondervan
1663 Liberty Drive
Bloomington, IN 47403
www.westbowpress.com
1 (866) 928-1240

ISBN: 978-1-9736-5502-2 (sc)
ISBN: 978-1-9736-5503-9 (e)

Library of Congress Control Number: 2019902333

Print information available on the last page.

WestBow Press rev. date: 03/21/2019

WESTBOW
PRESS®
A DIVISION OF THOMAS NELSON
& ZONDERVAN

Botanical REFLECTIONS

Capture Your Days in Words and Pictures

DORIS "AVIDHIKER2" LANCE

Question #1: What do you wish you had more time to do?

"As water reflects the face, so one's life reflects the heart."
Proverbs 27:19 NIV

Question #2: What has been one of your proudest moments?

"We are what we think. All we are arises with our thoughts."
Gautama Buddha

Question #3: How and when was the last time you pushed the boundaries of your comfort zone?

"We can never obtain peace in the outer world
until we make peace with ourselves."
14th Dalai Lama

Question #4: What book has left a lasting impression on you?

"Education is the most powerful weapon which
you can use to change the world."
Nelson Mandela

Question #5: What happened today that brought a smile on your face?

"Happiness is not something ready-made.
It comes from your own actions."
14th Dalai Lama

Question #6: How can you help others in your family, community, or at work?

"Being deeply loved by someone gives you strength,
while loving someone deeply gives you courage."
Lao Tzu

Question #7: What are your first thoughts when you wake up in the morning?

"Prayer is the key of the morning and the bolt of the evening."
Mahatma Gandhi

Question #8: How did you overcome one of the biggest challenges you have faced so far?

"Whoever walks in integrity walks secure, but whoever
takes crooked paths will be found out."
Proverbs 10:9 NIV

Question #9: If you could meet one person from history, who would it be? Why?

"Not all of us can do great things. But we can
do small things with great love."
Mother Teresa

Question #10: What could you donate (time, money, talent, clothing) to help the less fortunate?

"For to be free is not merely to cast off one's chains, but to live in a way that respects and enhances the freedom of others."
Nelson Mandela

Question #11: Record a holiday memory that brings you joy and happiness?

"Friends are companions on a journey, who ought to aid
each other to preserver in a road to a happier life."
Pythagoras

Question #12: What desires keep tugging at your heart?

"Thoughts disentangle themselves when they
pass through the lips and fingertips."
Dawson Trotman

Question #13: What problem do you want/need to solve in the next six months?

"Strength does not come from physical capacity.
It comes from an indomitable will."
Mahatama Gandhi

Question #14: What would you want others to know about you?

"Anxiety weighs down the heart but a kind word cheers it up."
Proverbs 12:20 NIV

Question #15: When you get upset, what are the ways you deal with it?

"Over every mountain there is a path although
it may not be seen from the valley."
Theodore Roethke

Question #16: What is missing in your life?

"Health is the greatest gift, contentment the greatest
wealth, faithfulness the best relationship."
Gautama Buddha

Question #17: How would you describe yourself?

"A good head and a good heart are always
a formidable combination."
Nelson Mandela

Question #18: Who are your heroes and why?

"If it is possible, as far as it depends on you,
live at peace with everyone."
Romans 12:18 NIV

Question #19: What does unconditional love look like to you?

"Kind words can be short and easy to speak
but their echoes are truly endless."
Mother Teresa

Question #20: What is the most creative thing you have done?

"We must build dikes of courage to
hold back the flood of fear."
Martin Luther King Jr.

Question #21: What skill or skills do you want to learn/develop?

"Live as if you were to die tomorrow. Learn
as if you were to live forever."
Mahatma Gandhi

Question #22: What habit would you like to break, and replace?

"Part of being optimistic is keeping one's head pointed
toward the sun, one's feet moving forward."
Nelson Mandela

Question #23: What are some of your greatest strengths?

"Give careful thought to the paths for your
feet and be steadfast in your ways."
Proverbs 4:26 NIV

Question #24: Who could you call, write or send an encouraging word, letter or text to today?

"Spread love everywhere you go. Let no one ever come to you without leaving happier."
Mother Teresa

Question #25: What are your hopes for the next year?

"Faith is taking the first step when you
don't see the whole staircase."
Martin Luther King Jr.

Printed in the United States
By Bookmasters